BLACK ROSES

BLACK ROSES
Odes Celebrating Powerful Black Women

HAROLD GREEN III
ILLUSTRATIONS BY MELISSA KOBY

HARPER
DESIGN
An Imprint of HarperCollins Publishers

BLACK ROSES

HarperCollins books may be purchased for educational, business, or sales promotional use. For information please email the Special Markets Department at SPsales@harpercollins.com.

First published in 2022 by
Harper Design
An Imprint of HarperCollins*Publishers*
195 Broadway
New York, NY 10007
Tel: (212) 207-7000
Fax: (855) 746-6023
harperdesign@harpercollins.com
hc.com

Distributed throughout the world by
HarperCollins*Publishers*
195 Broadway
New York, NY 10007
ISBN 978-0-06-313554-3

Library of Congress Control Number: 2021038111

Book design by Janay Nachel Frazier

Printed in Thailand

First Printing, 2022

THIS BOOK IS DEDICATED
TO MY GRANDMOTHER, BIG GIRL

CONTENTS

FOREWORD *8*

INTRODUCTION *10*

ADVOCATES *17*

ALLYSON FELIX — *Track and Field Sprinter* *19*

ANGELICA ROSS — *Transgender Rights Advocate* *21*

DR. EVE EWING — *Author of* Electric Arches *25*

DR. JANICE K. JACKSON — *Former CEO of Chicago Public Schools* *27*

KIMBERLY BRYANT — *Founder of Black Girls Code* *31*

KIMBERLY DREW — *Art Curator* *33*

RAQUEL WILLIS — *Director of Communications, Ms. Foundation for Women* *36*

STACEY ABRAMS — *Voting Rights Activist* *39*

TAMIKA MALLORY — *Women's March Co-Chair* *43*

TARANA BURKE — *#MeToo Movement Creator* *45*

CURATORS *48*

EUNIQUE JONES GIBSON — *Cultural Architect* *49*

MICHELLE ALEXANDER — *Civil Rights Advocate* *52*

NIKOLE HANNAH-JONES — *Creator of The 1619 Project* *55*

RAPSODY — *Rapper* *58*

TRACEE ELLIS ROSS — *Actor* *61*

ROXANE GAY — *Author of* Bad Feminist *65*

INNOVATORS *66*

BISA BUTLER — *Fiber Artist* *67*

ISSA RAE — *Actor* *71*

JANELLE MONÁE — *Artist* *73*

JESSICA O. MATTHEWS — *Inventor* *77*

SIMONE BILES — *Gymnast* *80*

TOMI ADEYEMI — *Author of* Children of Blood and Bone *83*

LUMINARIES

LUMINARIES — 86

CHARISMA SWEAT-GREEN — *Vocalist* — 87

JENNIFER HUDSON — *Musician* — 90

KEISHA LANCE BOTTOMS — *Former Mayor of Atlanta, Georgia* — 93

LISA GREEN — *Educator* — 97

LIZZO — *Musician* — 99

MANDILYN GRAHAM — *Mental Health Therapist* — 102

PHYLICIA RASHAD — *Actor* — 105

ROBIN ROBERTS — Good Morning America *Broadcaster* — 108

TABITHA BROWN — *Actor* — 111

TASHA BELL — *Financial Consultant* — 115

TRAILBLAZERS — 117

AVA DUVERNAY — *Filmmaker* — 119

BOZOMA SAINT JOHN — *Marketing Executive* — 121

DR. JOHNNETTA COLE — *Sister President Emeritus* — 125

KAMALA HARRIS — *Vice President of the United States* — 127

MELLODY HOBSON — *Investment Expert* — 131

MISTY COPELAND — *Ballet Dancer* — 133

NAOMI BECKWITH — *Art Curator* — 137

SHELLYE ARCHAMBEAU — *Silicon Valley Leader* — 139

ACKNOWLEDGMENTS — 142

FOREWORD

"Give me my flowers while I can still smell them," my grand-mother Laila used to say. I would hear her say this on the phone or when she had visitors over, or any time she received a small gesture of acknowledgment that she was thought about and loved. That quote seeded the inspiration for my second album, *Laila's Wisdom*, released in 2017 about the importance of passing down generational knowledge. As a kid growing up, I couldn't foresee how my grandmother's words would become the perfect analogy to my own blossoming and maturation as an artist. It also made me realize that in giving flowers to so many others, sometimes we forget to give to ourselves and smell the flowers given to us.

Fast forward to 2019, after the release of my third LP, *Eve*—in which I had titled every track after an influential Black woman to celebrate the spirit of who we are by seeing ourselves in some of our most notable representations through actors, poets, activist, entre-preneurs, entertainers, models, and more—I received a number of Instagram notifications about a poet whose spoken word perfor-mance dedicated to me brought me to tears.

"Become immortal. Just did it / Should be mentioned with Kendrick...never let the gender hinder the spittin." His words to my eyes.

I had spent much of my work planting seeds, cultivating, and watering my tribe of women that I forgot I was a Rose myself, so to hear the words so intently, poignantly, and profoundly acknowl-edging the light I have been blessed to be to others was a mirror. A mirror I realized I hadn't stopped to look in for myself my whole

career. No matter how much I had been showered by my close friends and loved ones (affirmations I never took for granted), it was something in his language of words from one poet to another that just moved me in a new way.

The individual holding that mirror was Harold Green, a spoken word poet writing odes to Black women he most admires. That day he was a florist, and with each new performance he released after celebrating another heroine, I realized he was one of OUR florists: sowing the ground for all Black women.

It always feels good to be acknowledged. And I've had my fair share—from BET to the Grammys to the *New York Times*. But there's something spiritual when it comes in such a raw and humble way—and from a brother.

It's important to note this was a period of time too when Black women were finding the union of voice, platform, and community to challenge the conversation of "how are our men showing up for us?" A time many of our sisters felt unprotected, unsupported, unloved, unwanted, and devalued by our brothers. The collection of poems here in *Black Roses* is a timely creative response to a call of action for love and recognition, and a reminder that there are still many brothers who see us as the sun to their moon. His words are reflecting our light to help those walking in the night find their way home; and for the ones already home, his moon is a reminder to not forget the stars.

As you travel the lyrical rows of this literary garden, I hope you feel the same fullness and love through Harold's words as I did. I hope you see and appreciate the seeds and sprouts before the blossom, and remember to tend to yourself. Marvel at your becoming and stop to smell the roses—such beautiful Black Roses.

—RAPSODY

INTRODUCTION

I grew up on the South Side of Chicago. My family lived in a two-flat in the Englewood area. My grandmother, Big Girl, lived upstairs with a constant rotation of my female cousins who stayed with her for various reasons. My mother, father, sister, and I stayed downstairs. Big Girl gave birth to twelve children—eleven girls (including my mother) and one boy. My father had two sisters and two brothers. I have fond memories of each of my aunties from both sides. Each of them poured into me one way or another.

On my father's side, Aunt Renee and Aunt Lisa loved taking us on "field trips" and affirming us: my aunt Renee would call my sister Doctor Green and call me Lawyer Green, and my aunt Lisa was (is) a quintessential "hypewoman" who will make you feel like you can do anything. From them, I learned the power of being genuinely excited for others and how prophetic an optimistic outlook can be.

On my mother's side, I learned so much from watching how my aunts carried themselves. Aunt Annette, Aunt Denise, Aunt Cheri, and Aunt Cathy taught me what freedom looked like. The way they laughed, lived, and brought the party wherever they went showed me the power of having a magnetic personality. Aunt Pam and Aunt Deborah taught me the power of taking

yourself seriously. As a child, I thought they were stern, and in turn, I always tried to be on my best behavior at their houses; what I learned was a lesson in how people will act accordingly in your presence depending on how you carry yourself.

Aunt Bertha and Aunt Janet showed me what having a heart looked like. They are two of the most caring and giving people I know. Aunt Melody showed me what mental strength is. She is one of the toughest aunts I have and seeing her continuously triumph teaches me the same lesson in new ways. Aunt Brenda taught me the power of intolerance. I never got the chance to meet her, but her devastating story of being a domestic violence victim always reminded me of what I wouldn't tolerate from myself—or from the men around me.

My mother and my grandmother were critical to my development growing up. My grandmother was not very verbally sentimental, but she loved me in a way that I could feel hundreds of miles away. She taught me how to love without having to say I love you. My mother showed me what it means to be selfless. There are so many times in my life that I remember my mom putting herself third or fourth just to make sure we knew love, opportunity, or options.

My sister, Mandilyn, and my wife, Charisma, are two of my best friends and also play a large part in that ecosystem of Black women who have taught me how to be. When I first started

writing poetry, my sister was one of the first people to tell me I should take it seriously and pursue it—she has shown me what unwavering support looks like. My wife has been one of the most consistent artistic collaborators I have had the honor to work with. She has continued to show up for me in ways that are tangible and ways that are unquantifiable. She has shown me the value of being present.

I have known Black women in very intimate ways for as long as I can remember, and they have taught me and shaped my ideology on the beauty, power, and worth of Black women and life. So many of the educators who have molded my mind have been Black women from preschool to college. I think about these women and how often this is the same case for so many kids, especially those in Black communities, so I truly believe we owe Black women many thank-yous for all that we have become.

Black women have given us so much but continue to receive so little. Through *Black Roses* I am hoping to present some reciprocation. I want to create emotional equity. Oftentimes when we think about equity, we think about it in financial terms, but I want to explore the idea that those who have had to suffer centuries of not only physical abuse from a nation, but also verbal and mental abuse, deserve not only economic but emotional equity. For an unfathomable amount of time, Black women have been reduced to stereotypes and rarely lauded for their brilliance, character,

and contributions as they should. They continue to work hard (oftentimes for lesser pay), lead movements and homes, fight for themselves and everyone else. More than anyone, they deserve a surplus of affirmation and consideration daily. I wrote this book in the hopes of adding to that surplus.

I began writing this project in the fall of 2019. The first subject was Rapsody. I am such a fan of her work and her consistency. Her album *Eve* had just come out and I couldn't stop playing it. I wanted to find a way to express to her how much she meant to me and I couldn't think of any better way than using my gift to say thank you for hers. As soon as I came up with the idea, I knew I wanted to expand on it and tell more Black women who I admired: "Thank you." This concept felt organic to me because my whole artistic career of writing poetry, plays, and music, and curating live art experiences has been based around giving *Flowers for the Living*, which, for me, means making sure that people feel loved and affirmed while they are still here. I'm on a mission to wrap people up in my work and make them feel like they have a home there, and proclaiming the multifaceted beauty of Black women is one of my favorite topics because so often they love, support, fight, and care for others without receiving the same in return.

Once Rapsody saw the video of me reciting the poem I wrote for her, she reposted the video and sent me a very heartfelt

message. I was so overwhelmed and emotional that someone I respected so much felt honored by my work. Then, Ava DuVernay retweeted the video I posted of my ode to her. I was in the gym when it happened, and I stopped to read the message she wrote. I had tears in my eyes talking to my sister about it. I was barely able to finish my workout.

One Sunday, Tracee Ellis Ross saw the video I posted with her ode and reposted it on her page. I was making breakfast and I stopped, went around the corner, and cried for so many reasons. It was such an emotional moment because I thought that she was never going to see hers and once she did, her reaction inspired me so much and motivated me to continue the project further. Once the idea of *Black Roses* becoming a book came to fruition, I was determined that this wouldn't be the last one. I dream of *Black Roses* being volumes long. I want to continue this work for decades because Black women deserve this emotional equity.

One of the greatest joys in composing this book was the opportunity to sit with the rich stories that these women have lived. Intensely researching each *Rose* was such a pleasure. To learn that people like them existed gave me more joy and hope as a human being. And the greatest joy, by far, was the opportunity to add women from my family to this book among women

they admire and applaud, because, in my eyes, the women in my family are stars in their own right.

By the time this book comes out, these women will have achieved more than when I first started writing about them, so I wanted to make sure I spoke to their timeless character traits; the things we will remember most about them is how they continue to make us feel. I want you to feel their existence; that is my job as poet—to put form to sentiment. This is not a biographical work; this is a celebration in the form of affirmations.

I hope that Black women feel seen within this book; even if their names aren't mentioned explicitly, I hope they know that I am talking to them as well. I hope that Black men find inspiration in this book to be better friends, lovers, admirers, cheerleaders, record keepers, protectors, and safe havens for Black women. So many of us feel the same way I do about these women and I just wanted to create the language for those feelings. I wanted to demonstrate how we should start talking to and about Black women. I wanted to create a template for emotional equity.

It's not only important to *say her name*, but we must also *celebrate* it as well. So, I implore you to look more into the lives of these amazing women; their résumés are "a work in progress," so let's continue to spread their stories.

Let's *celebrate* their names now:

Allyson Felix, Angelica Ross, Ava DuVernay, Bisa Butler, Bozoma Saint John, Charisma Sweat-Green, Dr. Eve Ewing, Dr. Janice K. Jackson, Dr. Johnnetta Cole, Eunique Jones Gibson, Issa Rae, Janelle Monáe, Jennifer Hudson, Jessica O. Matthews, Kamala Harris, Keisha Lance Bottoms, Kimberly Bryant, Kimberly Drew, Lisa Green, Lizzo, Mandilyn Graham, Mellody Hobson, Michelle Alexander, Misty Copeland, Naomi Beckwith, Nikole Hannah-Jones, Phylicia Rashad, Rapsody, Raquel Willis, Robin Roberts, Roxane Gay, Shellye Archambeau, Simone Biles, Stacey Abrams, Tabitha Brown, Tamika Mallory, Tarana Burke, Tasha Bell, Tomi Adeyemi, Tracee Ellis Ross.

ADVOCATES

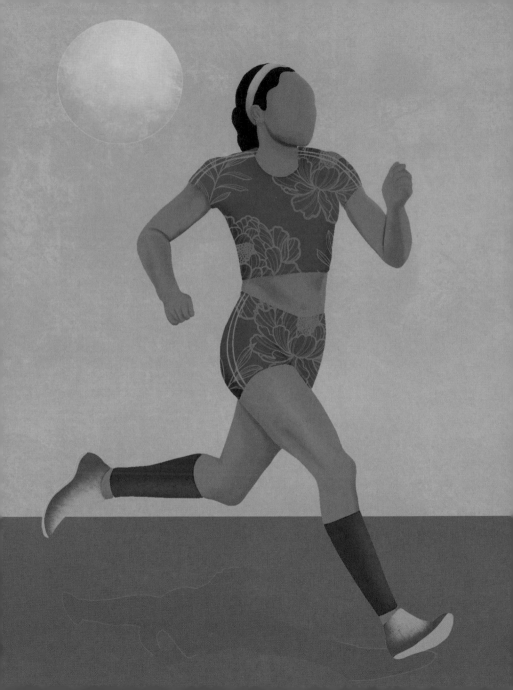

ALLYSON'S MARATHON

ODE TO ALLYSON FELIX

On your mark:

With eyes piercing through time
to realize
that the future relics
on not just what you do in relays,
but on what you did
and didn't say.

To understand the biggest triumph
is not broken records,
but broken silence.

For *Camryn* to know
Mommy isn't just a runner,
but a fighter.

The audacity of motherhood—
to face death
just to give life.

To live in fear
they may strip you of your shine
if you don't fall back in stride.

How easily they dismiss you
if you not making good on time.
I guess breastfeeding and human-bearing bellies
don't meet their bottom line.

How dare you not think about a medal
when you're on a hospital bed dying
just in hopes of hearing your baby crying.

But who gon' check you
when you not doing it for the Check.

Get set:

With feet braced on tracks
never meant for sprints.
Slow and steady savor this race.
You create your own pace.
Where hearing "mom"
will get you off the blocks
faster than any starting pistol.

What a joy
to discover that who you were running for
is now running you.

How selfless of you
to fight for the future
knowingly risking the now.

But you've trained for this.
You know better than most
long distance takes endurance.

Athlete, Champion, Olympian.

But **Mother** is the most honorable title you know.

Go!

ANGELICA'S POSE
ODE TO ANGELICA ROSS

We don't always ask to be
the poster child, representative,
or spokesperson.

Sometimes, just being our fullest selves
makes us an expert.

The way you show up,
has shown others
the value of their presence.

The way you show out,
has given others a reason
for excellence.

What happens when your body
is a political statement?
When every move you make,
there is a critic waiting?
You become undeniable.

You are talent
and teacher.

You are victorious
and vast.

Your posture
makes onlookers fix theirs.
You turned an *American Horror Story*
into a dream come true.

Self-love looks a lot like liberation
and you look emancipated.
The way you dig into your truth.
The way you bring others with you
and create home
for those too far from it.

You are a bridge builder,
even on the days you need one.

No matter the fog,
you've stayed focused.
You provide benchmarks
for those who've felt hopeless.

You are so sure
and fully committed
to being a beautiful person.
It makes you wonder,
who's really posing?

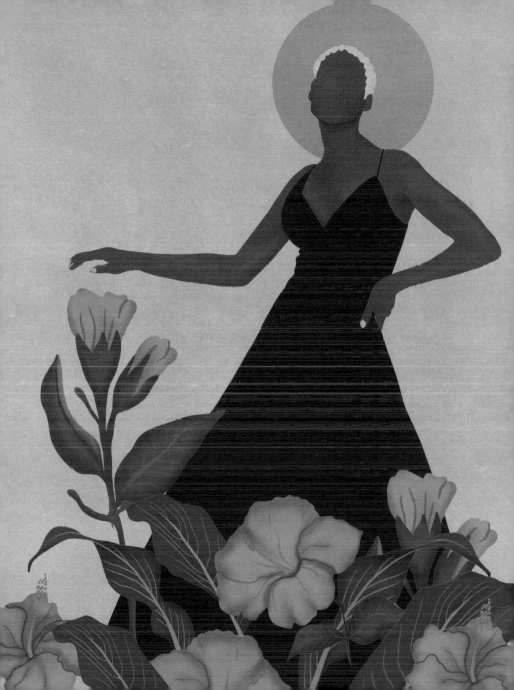

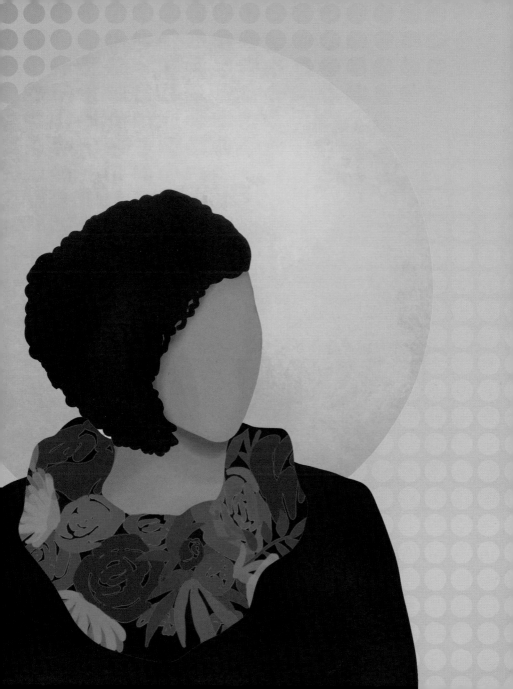

EVE'S LOYALTY
ODE TO DR. EVE EWING

Have you ever seen someone love so hard
that they learn everything they can about you
just so they can remind you who you are,
how you started,
and how far you have to go—
just so you never forget the mission?

Have you ever seen someone love so hard
that they talk about you so passionately,
so vividly,
so clear,
that it forces people to listen?

Have you ever seen someone love so hard
they continuously create the best version of themselves
so they represent you well
no matter where they go?

Have you ever seen someone love so hard
that people see you in them
no matter where they go?

Have you ever seen someone love so hard
that even when you break their heart
they still keep it open for you?

Have you ever seen someone love so hard
that even when you break their heart
they still won't let nobody
say nothing bad about you?

Have you ever seen someone love so hard
that they write love letters about you
and share them with the world?

Well, that's how much Eve loves Chicago.
A transformative love.
A love that looks you in the eye
and tells you,
"I know what you're made of."
A love that doesn't let go.

We can all learn from the way
Dr. Ewing loves Chicago.

DR. JACKSON'S PRINCIPLES

ODE TO DR. JANICE K. JACKSON

There are a lot of rusty parts
in a broken system.
Who better to fix them
than someone who has seen all of them
up close and personal?

Success is inevitable
when you take progress personal.

The product of proletarians.
Momma was a dispatcher,
Daddy drove cabs,
now you call the shots
and the driving force
behind an entire district.

No small dreams
when you want to make a big difference.
You spoke yourself into existence.
You didn't wait for people to listen;
now they have to.
Even the critics
realize it's hard to dismiss you.

I've seen the way you care—
it's no act.
I've seen the way you lead—
there's no lack.

This country loves to hand over a mess
to a Black woman
and say,
"Fix it."

And when they do,
with the style, grace, and precision
that only they can,
you are left wondering
where the credit is at.

The criticism
is always louder than the celebration.
But, your vision is so clear—
you see past that.
Your truth is so loud—
they hear you in the back.

So, don't mind me—
I just came here to clap.

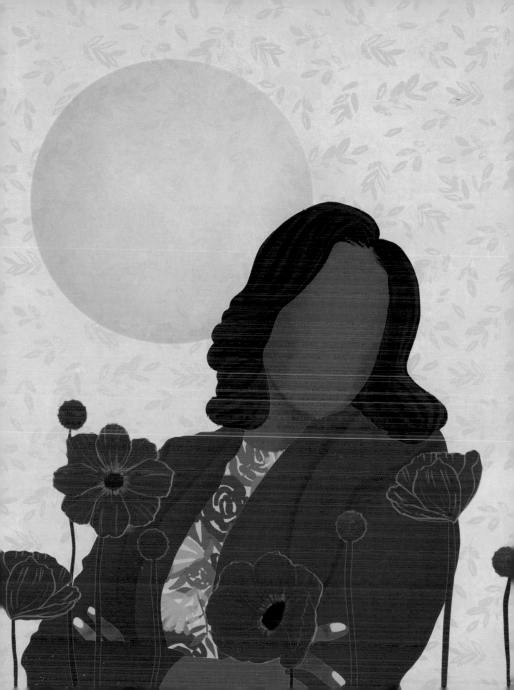

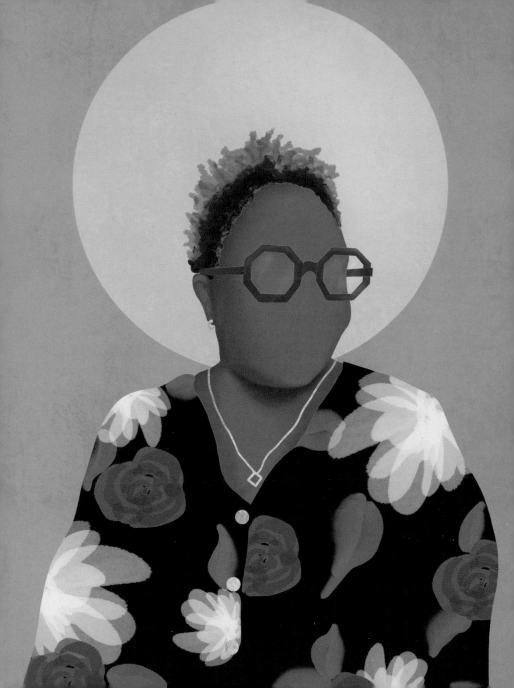

KIMBERLY'S LANGUAGE
ODE TO KIMBERLY BRYANT

Language can be a barrier,
when it's foreign,
but a translator can open the world to you.

The more languages you know,
the more freedom you have—
and when your translator
becomes your teacher
that's liberation.

Code is language.
Kimberly, you are a linguist

How bold,
how altruistic,
to see a problem
and create a solution.

To see *Kai*
and start a revolution.

You are building an army.
One million *Shuris*—

so sure of themselves
because they can speak the language.

You are a general—
highly decorated
and highly capable.

From Oakland
to Johannesburg,
you are turning Black girls
into leaders.

You are the algorithm
and the anthropologist.

You are the engagement
and the engineer.

Keeping Black women out of anything
is highly unsustainable.
So, we owe you a thank you
for giving technology an upgrade.
For giving Black girls community.

You are leveling the playing field
for all those that lacked an advantage.
They tried to keep you out of the conversation,
so you created a new language.

KIMBERLY'S COOL
ODE TO KIMBERLY DREW

Wayfinder.
Doormaker.
Eyeopener.
Receiptbuilder.

You are a compound word—
an amalgamation of curation.

This Is What I Know About Art:

You are making Black
a primary color,
and your blends
know no end.

You are teaching perception
how to bend.

You show past and present
how to be flexible
and make way for
Black Futures.

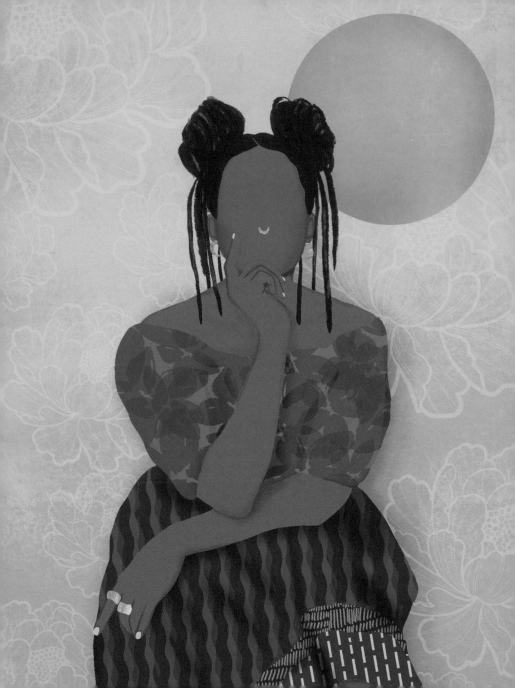

Art is fashion,
which means—
you are a portable exhibition.

Art is essential—
like breathing,
or vision.
We see what you see.

Art is for the living.
It helps us understand our existence.
There is an art to comprehension.

You turned equity
into an art form
and made it exquisite.

You put it on display
for all to see.
Met us where we were
and invited us up—
how hospitable.

You made the hidden visible.
Look at the picture you paint.

Everyone, look at what Kimberly drew—
a collage of self-portraits
for us all to view.

RAQUEL'S RESPECT
ODE TO RAQUEL WILLIS

Who fights the most
for those who receive the least?

The most stares,
but least empathy.

The most judgment,
but the least grace.

Your words
have created a safe space.
You push the conversation forward—
just by moving forward.

You refuse
to be docile.
You have given hope
that a brighter future is possible.
One where they not only exist—
but flourish.

Your success
sustains imagination,
but even without it—
you deserve your heart's desires.

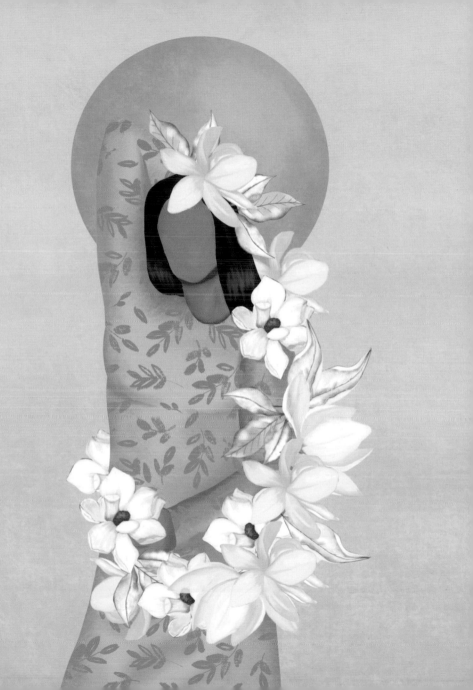

But until those who are given the least
are met with more,
you continue to set the page on fire
with the proper balance
of passion and ire.

It's painful
to fight for everyone
and feel unprotected.
To show up for those in need
and feel neglected.

But you keep finding the language
to make people feel they are not alone.
You've given your heart,
to help people feel at home.

But you continue to push against the **red** line
until it is no more.

You are creating space for all of us.
And for that,
We owe you more.

STACEY SPEAKS

ODE TO STACEY ABRAMS

You ever hear someone speak so gracefully
that they made complicated ideas feel like ballet?
Some folk tiptoe around the issues,
but she stays on pointe—
to the point you can't escape it.

You ever hear someone speak so constructively
that their words built a structure around you?
A safe space,
or closing walls,
depending on what side of things you're on.

You ever hear someone speak so convincingly
that you forgot what side of things you were on?

You ever hear someone speak so sharply
that they cut through—
~~Red tape~~
~~Redlining~~
~~Bureaucracy~~
~~Fake democracy~~?

The commas be chopping.
The sentences be slicing.

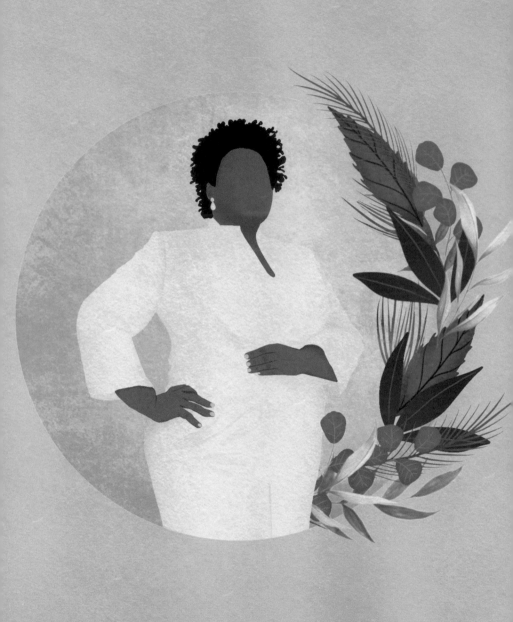

You ever hear someone speak so confidently
that you forget how doubt feels?
As if self-esteem can be transmitted through oration.

You ever hear someone speak with so much patience
that it makes you question
if being pensive has its payoffs?

You ever hear someone speak so genuinely
that you remember you believe in people
and not politicians?

Stacey talks like she believes in people
and that's why she became a politician.
Like she was told,
"Having nothing is not an excuse for doing nothing,"
so she's always doing something.

Stacey speaks like she went to **Spelman**.
If you've never heard it—
it sounds like a Black woman
who won't stop until she fixes a broken system.

When *Stacey* speaks,
I think we should all listen.

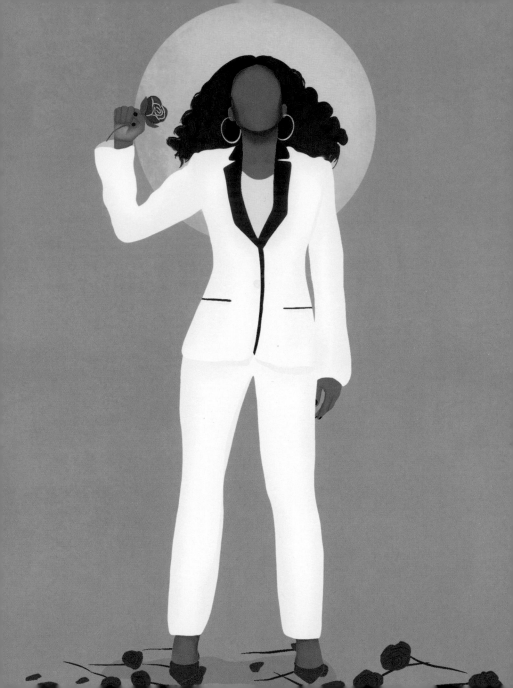

TAMIKA'S MARCH
ODE TO TAMIKA MALLORY

Ms. Voncile and *Mr. Stanley*
did an amazing job.
They birthed a *Harlem Renaissance*
with a *Bronx* mentality.

You've scripted testimonies from tragedy.
Through horror—
you've found humanity.

When your heart broke—
you found ways to put the world back together.
I know *Jason* is smiling down at you.

The job of a leader can be thankless.
The ways of an activist can be selfless,
but I know *Tarique* is proud of you.

All those nights on the road—
just to pave the way.
All those days of rage—
just to find the right words to say.

This is a **Black Parade**
and you're a *Grand Marshal*.
A whole revolution,
but I'm partial.

We owe you more than a thank you.
We owe you our best.
We owe you effort—
on days we feel like caving.

We owe you passion
and patience.
We owe you reciprocation
for the dedication you've shown us.

To look evil in the eye
and spit fire.
To know the journey
and not fear tired.

Such power.
What a presence.
Young, *Gifted*, and **Black**
A present.

Your upbringing
will always come back around.
You are doing the work of cycles.

A woman.
A fighter.
Lead the way—
we are right behind you.

TARANA'S FREEDOM

ODE TO TARANA BURKE

The beautiful thing about freedom—
is the ability to *Just Be*.
The bliss in the "exist."

And for every limitation
placed on that verb,
the tighter the proverbial walls feel.

Sometimes those walls have spikes.
or fire,
and they close quicker on some than others.

Those walls can leave scars.
Leaving the victim searching for ways to heal,
and some find a way to run through walls—
so others know freedom.

You break down walls
and never claim to be a healer,
or fixer;
but a great listener.

There is freedom in being heard.
There is liberation in words.
There is power in community.

Two words to let it be known it's not just you—
Me, too.

But it's so much more than the gathering.
Freedom is a shift in mentality—
from *victim* to *victor,*
from *survivor* to *thriver.*

The power you've given others—
is the chance to be released from prison.
That's what happens when we listen:
The stories that bind us—
relinquish their power.

But, not only do you tear down walls,
you are a door holder—
with your arm extended
to show your scars exist, too.

You are strong enough
to make the world listen,
and get uncomfortable,
while you keep going;
even when the moment has passed.

But never forget—
you deserve love, too.

So, whenever someone says,
"I love *Tarana Burke,*"
the world should say,

"Me, too."

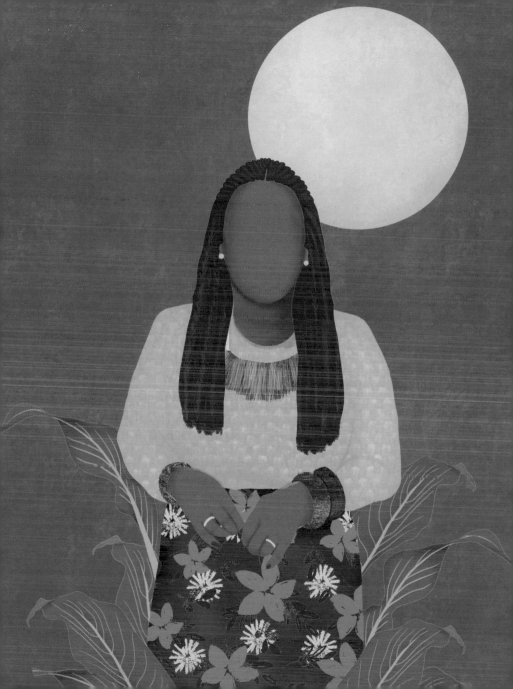

CURATORS

EUNIQUE'S VISION
ODE TO EUNIQUE JONES GIBSON

A mirror
not only shows you a reflection,
but who's behind you—
a rear view.

And *Because of You*
we have hindsight.
You have gently lifted our chin up
to remind us
how beautiful we are
whenever we forget,
or just never knew.

We are never too young to have pride,
never too old to learn something new,
never too scared to be brave.

It's never too late to be you.
To be young, gifted, and Black—
To be you.

Look what you've taught us
and just to think how it started.
You plan it for *Mars*,
Chase the dream,
and *Sage* the culture.

Building a legacy
for your *Legacy Defenders*.
Who reaps the benefits of the farmers?
Children of the harvest.

You've taught us
There are a thousand ways to be resourceful
in the spirit of a *Dr. George Washington Carver*.

You've turned it into **Black History Year**
in the spirit of *Carter G. Woodson*.

Who told you to be this bold?
To be Black and spread love.
To combat negative with positive.
To see problems
and find solutions.

Your dedication is a revolution.

A mirror
can show you the future
just by looking at the present.
The beauty marks, the scars—
they tell it all.

You have forced us
to look at the mirror
and smile,
we hadn't done that in a while.

Because of you,
hope feels real.

Because of you—
WE will.

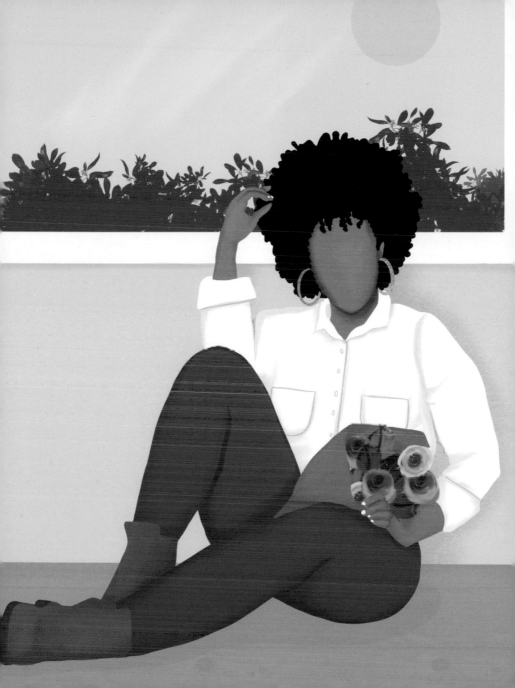

MICHELLE'S REVELATION
ODE TO MICHELLE ALEXANDER

The best do-gooders
are the ones who realize
that they can do better.

When we are not bound
to our preconceived notions
of how it all works,
and who it all affects.

Real revolution starts with revelation.
When we realize our imagination
is limited by our reality.

Real revolution starts
with self-evolution.
When we realize
that we cannot conquer the problems of the past
with antique artillery.

And to accept these notions
becomes ancillary to progress.
You have chosen to accept new truths—
uncomfortable and unwavering.

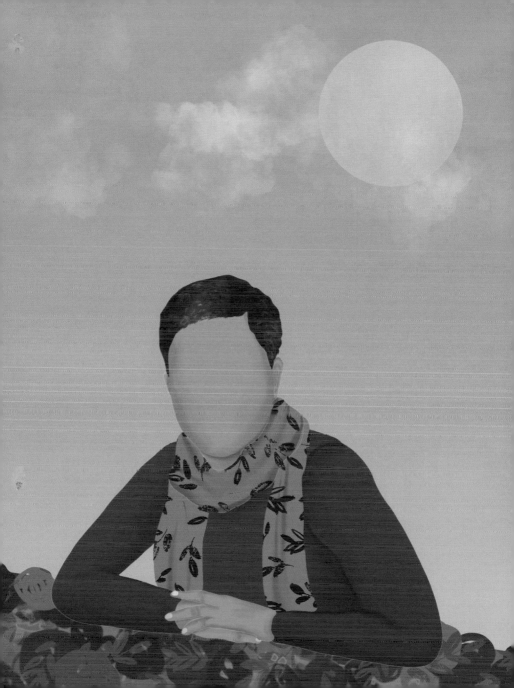

You have looked us in the eye,
told us to accept it or not,
but you are moving forward.

On a mission that requires millions,
you are unafraid of the number one,
because, isn't that where all revolutions start,
with **one**?

Your belief in breaking down walls
and building a new future
is so clear—
that we can see it, too.

You taught us that
confinement has a center,
but so does freedom,
and that center is you.

NIKOLE'S DEMOCRACY

ODE TO NIKOLE HANNAH-JONES

Moses parted the Red Sea
to set his people free.

Nikole parted her red fro
and told America
to give her people what they are owed—
while resurrecting the spirit of *Ida B.*

It's all Biblical,
and denying documented history is blasphemy.

Slavery then,
Segregation Now,
to reparations when?

The way you craft the narrative,
present all the points,
and ask the right questions—
a master storyteller.

Teaching us all a lesson—
with an efficient rage
that burns like a furnace.

With perpetually manicured nails—
to let you know
she's always prepared
to scratch below the surface.

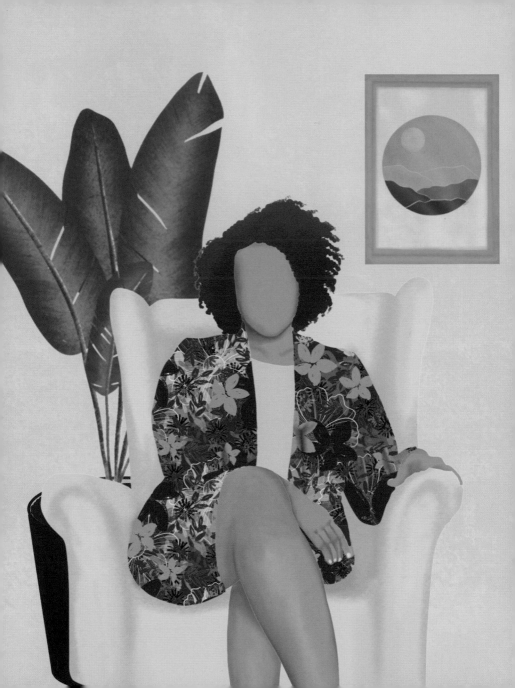

Reexamining our past
in hopes to reimagine
Najya's future.

Young, gifted, and Black.
A *Pulitzer Prize.*
A *MacArthur Grant.*

You have shown us—
the power in looking back.
You have provided us with
the warmth of other suns
just by telling the truth.

We have options.
From the *White Lion*
to the White House,
our story can no longer be left out.

You have reframed the way we recall;
and for that,
you are the most American of us all.

RAPSODY'S WISDOM
ODE TO RAPSODY

The beauty of the Sankofa
is the ability to hold on
to what's valuable behind us,
while still facing forward—
never forgetting the treasure of the past;
simultaneously, never forgetting
the importance of progress.

Respect for those before you,
but there will never be another you.
It's too sticky walking in a Tarheel's footsteps.

A goddess MC
with a Nike complex.

Change the conversation,
Just Do It.

Personify determination,
Just Do It.

Become immortal,
Just did it.

Should be mentioned with the illest.
Ask your favorite
who's their favorite,
they get it.

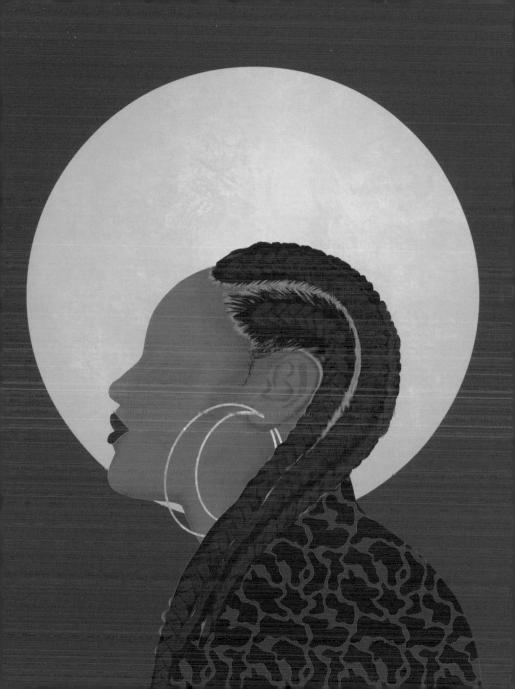

Never let her gender hinder
your opinion.
Culture don't come from the critic,
but from the creators who live it.

You are the culture.
We should be thankful to witness—
a warrior
with an indomitable spirit.

Remember when you yelled,
"I'm great!"
and they wouldn't listen?

Now we speak your truth
and dare them to resent it.
The payoff of perseverance.
The decadence of different.

Wear your crown like a fitted—
a New Era.
Baton carrier.
Torch bearer.

May your light shine—
L-E-D.

You got a whole nation behind you—
R-O-C.

Long live the legend—
R-A-P.

TRACEE'S JOY
ODE TO TRACEE ELLIS ROSS

Her laugh sounds like reparations—
like payback
for plight and plantations.

She laughs for times
we were unfamiliar with jubilation.
It almost sound like
science fiction.

Unimagined realities and
alternate universes
exist in her bliss.

When someone's delight makes you smile
that's transformative.

Her laugh is a revolution.

We are all watching a master of one
who reminds us self-love
looks like strength.

Solitude—
looks like a gift.

Everyone's imaginary BFF.
Her laugh sounds like no regrets,
like a teachable moment
wrapped in a nonjudgmental tone.

Her laugh looks you in the eyes
and makes you feel at home.

And her hair is a dissertation,
heavily citing research of trees.
Our roots tell a story
and we control the narrative.

Her passion and perseverance
dictate that the right *Pattern*
could break the mold.

Her laugh sounds like independent study,
like it chose its own coarse.

And of course,
she laughs with her mouth open—
she needs you to see what freedom looks like.

Her laugh is an abolitionist.

It has its own identity
and language . . .
and monologue . . .
and introduction . . .

It says, "I wasn't always this way,
but I'm happy for the journey,"
Like it's so excited to no longer be hiding.

Her laugh is a liberation for all of us.

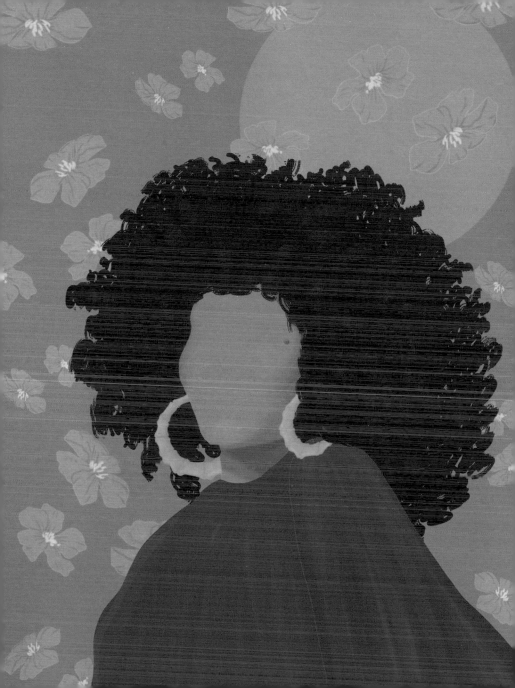

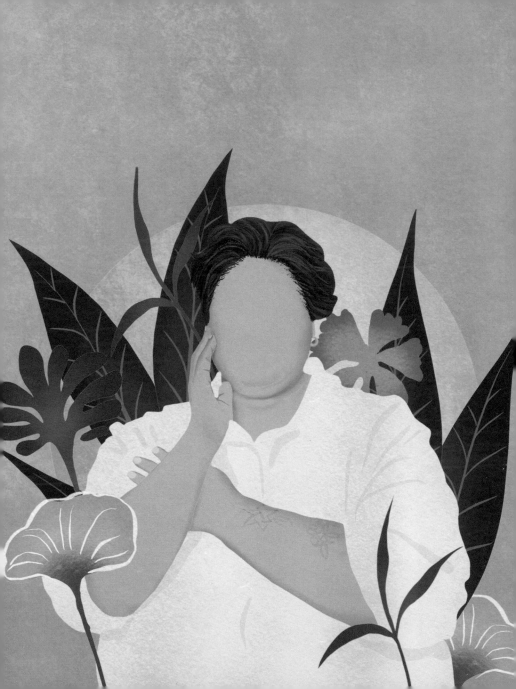

ROXANE'S WAY

ODE TO ROXANE GAY

One of my favorite things is your laughter.
It comes from such a deep place.
How red it turns your face—
reminds me of an *Age of Innocence*.

The conversation you have started
keeps shifting.
And you're daring us to keep up.
Your endurance is one to *Marvel* at.

An indescribable fortitude
that never seems to cease.
And a ferocity that runs as deep—
as your Haitian heritage.

With a *Hunger*
to not be the hero,
but the interrogator.

Which is a labor of love—
with inconsistent pay.

When you are as good as you say,
it makes some uncomfortable.

No contortionist.
You break the boxes
and the rules—
when you see fit.

You blur the lines of genre,
but I see you so clear.

You help us never forget
that you are here.

INNOVATORS

BISA'S SUPPORTING DETAILS

ODE TO BISA BUTLER

Your attention to detail
makes certain
that the diaspora doesn't disappear.

Beautifully bold
and aesthetically audacious.
An array of Kool-Aid colors
Grape, Strawberry, Fruit Punch.

You can feel the flavor.
As refreshing as the cultural concoction
on a sweltering summer day.

You create people of color—
vibrant in every way,
with all the dimensions
that we embody.

Denim on lace.
Chiffon on leather.
We are a diverse lot of textiles
and you have figured out
how to interlock our presence.

But I believe,
this is a long line of self-portraits.

You amplify our glory,
you tell our story
through stitches,
but you serve as canvas, too.
Artist and subject.

Your imagination
is only broadened by your reality.
A museum of motherhood.
Not only did you birth *Temi* and *Santi*,
but also sensation.
An heirloom
passed down through generations.

You've shown us,
and the world,
our good side.

You've helped me realize
that a stroke of genius
can also be a stitch in time.

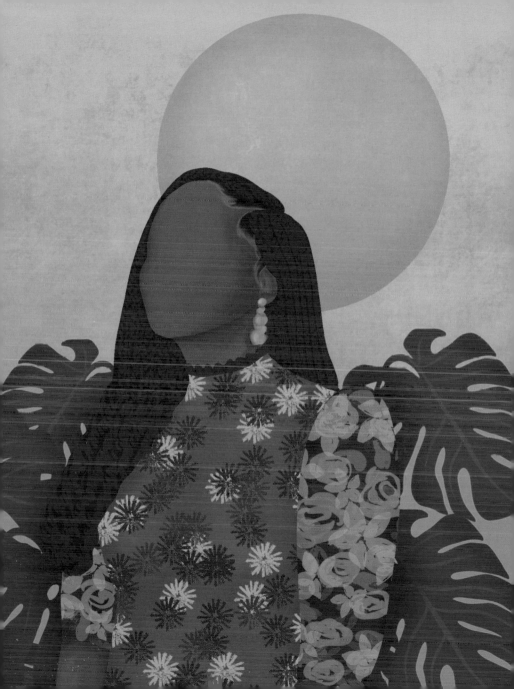

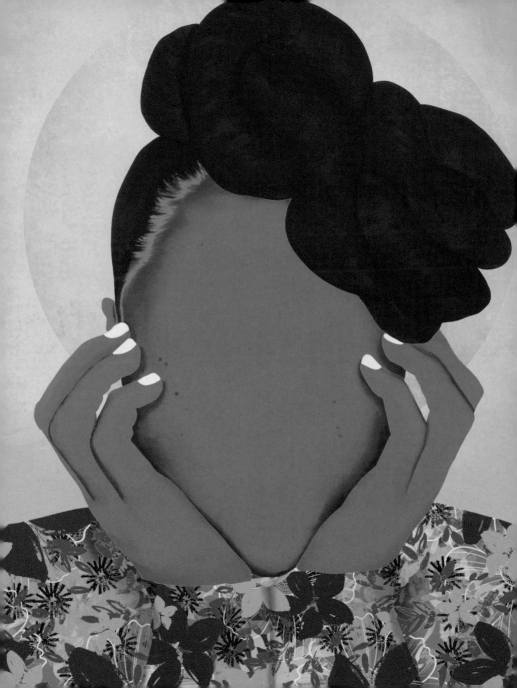

ISSA'S ADVENTURE
ODE TO ISSA RAE

There's something they don't tell you
about paths less traveled—
you meet people along the way.

Issa's path was unpaved—
filled with gravel, mud, and debris
that made her stumble on many days.
But on her journey,
she realized she wasn't alone.

The Black girl struggling to find identity,
in the midst of a male-dominated society,
reminded her of herself.

And seeing Issa find her footing
helped her lay bricks for herself.

There's something else they don't tell you
about the path less traveled—
you won't always be by yourself.

As Issa traveled along,
her balance got better,
the road became clearer,
and when she looked back—

she realized that
she had created a trail
long enough for those she met
to follow along—
and if they got lost,
she was the map.

Building a path can be scary.
It leaves us exposed
and vulnerable
but you've shown us
how to turn awkwardness into an asset
and how invaluable our insecurities are—
it shows us who we are
when no one is looking.
You showed us how to conquer our fears
when everyone is looking.

On the path less traveled,
there may be lions, tigers, and bears—
but you're the bravest of them all.

Issa,
thank you for taking us on this adventure.
We're rooting for you.
You've been an inspiration to us all.

JANELLE'S IMAGINATION

ODE TO JANELLE MONÁE

The year is 2007,
and little Janelle wakes up
from what she believed to be a daydream,
in the middle of *Mr. Ammonds'* class,
to see a petite, full-haired, brown-skinned woman
tinkering at a workstation.

On the wall
there was a large sign
that read, *The Chase Suite.*

She asked, "what are you making?"
Without turning,
the woman said,
"an android."

She asked what her name will be.
She said,
"Cindi."

As the lady began to turn,
the room began to spin.

Little Janelle was now standing in 2010,
in what looked to be

a church with no pulpit.
No signs of saviors or such—
just pews of androids.

She noticed a book
that looked a lot like a Bible,
but the title said, *The ArchAndroid*

She again saw the petite woman
with her back to her,
In what appeared to be a robe.
And she seemed to be
baptizing the androids
in what looked to be a tub of gold.

She felt too far away to ask any questions.
So as little Janelle began to approach,
the brown-skinned woman turned.
From her eyes shot a light beam
that blinded little Janelle.

By the time she focused her sight,
she was in 2013
now in what looked to be a warehouse
filled with androids.

She again saw the full-haired woman
in a black-and-white lab coat,
with a name tag that said *The Electric Lady*,

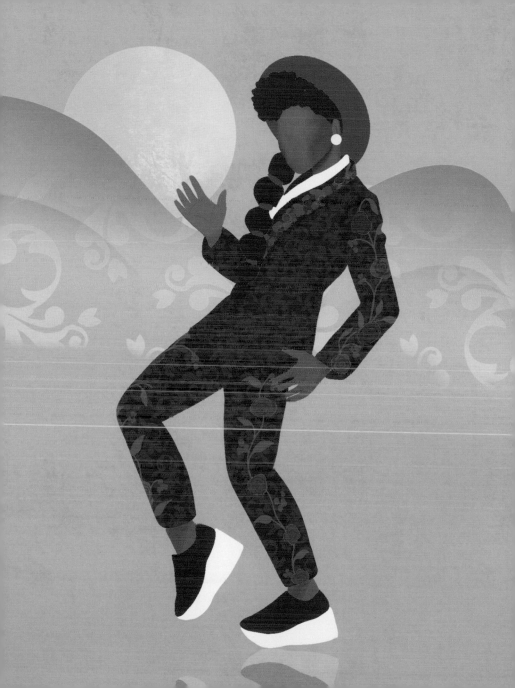

tending to her creations with great care—
all shining in gold.

"Excuse me," whispered little Janelle.
The lady turned
with a smile she'd never seen.

The room vanished
and she was in 2018
in a stadium
filled with androids and humans alike
dancing together.
The androids' gold rubbing off on the humans
without notice.

The petite, brown-skinned, full-haired woman
appeared on stage.
She seemed to be floating
and holding a *Dirty Computer.*

But this time,
little Janelle seemed to have a perfect view—
front and center.
They locked eyes
and the woman of her dreams said to her,
"I exist because of you."

JESSICA'S LIGHT

ODE TO JESSICA O. MATTHEWS

There's a blackout in Harlem,
and you are the light.
When so many wanted to be first,
you were more concerned with being right.

Nigeria must be proud of you.
You must be proud of you.

You are changing the way we move.
Kinetic currency.
Intellectual property.
That's money moves
and brain buildings.

You're a landlord
and a trainer.
A rejection refuser
and success sustainer.

You took small points of pain
and became a big-picture painter.
Those closest to the problem
have the best vantage point for solutions—
and your vision is crystal clear.

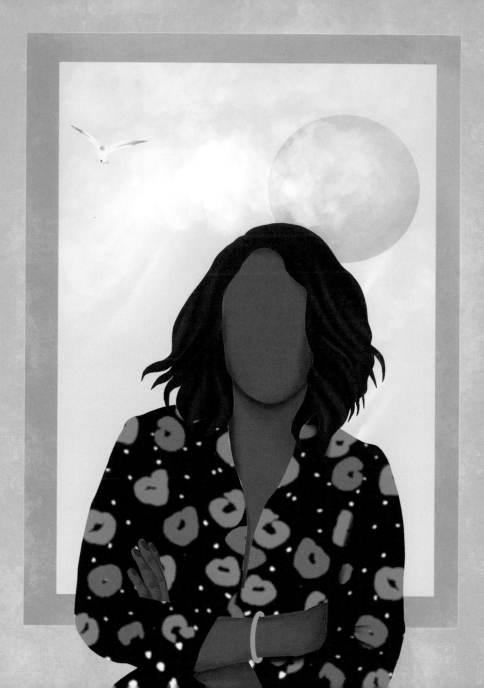

You know why you're here
and you're on a rampage to prove it.
Filled with a passion for progress—
on a mission to never lose it.

A dual citizen.
A double threat.
New ideas
can solve old problems.
A Rookie Vet.

You found rhythm in rotation,
lessons in linear compression,
and synergy in sliding.

Genius is the ability
to see what's hiding
in plain sight.

Your genius is so bright.
You never had to turn your Black down
to show us your light.

SIMONE'S WINGS
ODE TO SIMONE BILES

<u>You are so rebellious</u>
that you decided to defy gravity,
ignore all the rules,
and *fly*.

I've never seen a human being
transform like you.
You saw how *uneven* the *bar* was
and decided to just raise it.

You kept going
until you found *balance*.
You *vaulted* into our hearts
and onto podiums
with laser-*beam* focus.

Maybe it's because *Ms. Nellie*
showed you how to see your goals
before you crushed them.

And maybe it was *Mr. Ron*
who taught you how to build wings.

In turn,
you have taught so many how to dream.

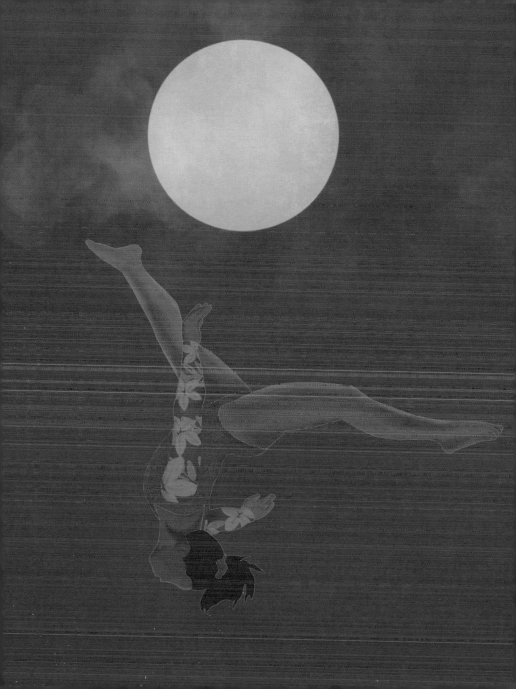

You are so rebellious
that you defied physics
and became gold.
You may be one of the best alchemists
this world has ever known.

So many of us live—
with the fear of the unknown,
but you had the courage to soar
not knowing where you would land.

But look at you,
both feet firmly planted in history.
Pushing through pain
with all that pressure
piled atop your petite frame.

What a degree of difficulty.
And I know
all of life's tumbles
can take their toll.

But you've shown us that—
coming up short
doesn't have to alter long-term goals.

You've shown us how to fly,
And **that** is gold.

TOMI'S MAGIC
ODE TO TOMI ADEYEMI

I wonder if you have realized
that you are the magic you write about.

I wonder if you know
you've written an autobiography.

You are the *connector*
and *seer*
that has turned so many into believers.
What a feat.

As people turn pages,
they erupt into uncontrollable praise dance.
You've seeped into their spirit
with the skill of a *reaper.*

Tears flood from their eyes
as you help them realize
how strong their powers are.
Is that not a *tider?*

You write with the passion
of inextinguishable forest fires
set ablaze.
Is that not a *burner?*

Through your stories—
you aim to cure the ills
that we try to just bandage.
Are you not a *healer*?

You've created a whirlwind of celebration
and representation.
Are you not a *winder*?

You've taken what this world has given you
and built a whole new one.
Are you not a *wielder*?

All while illuminating the dark corners,
because you are a *lighter*.

You trained your inner dragon
to emit fire on command,
because you are a *tamer*.

But your mightiest superpower—
is writer.

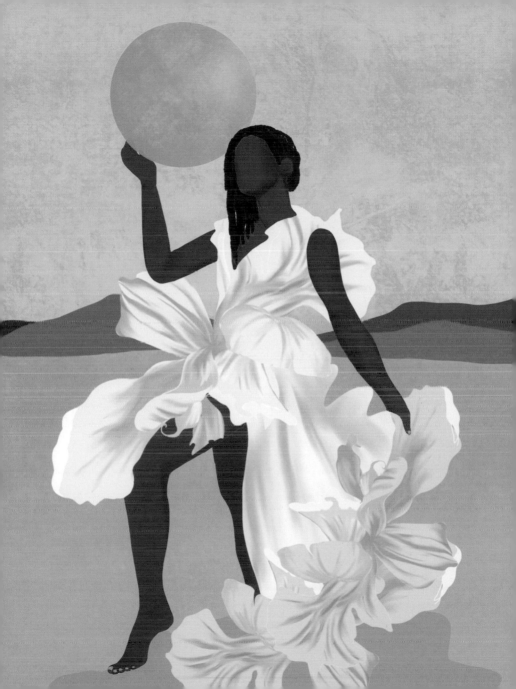

LUMINARIES

CHARISMA'S PERFECTION
ODE TO CHARISMA SWEAT-GREEN

Your journey through the *Mothership*,
right into *Mr. Curtis Sweat*'s arms.
Perfect.

The way that confidence emits from you.
Perfect.

The way your smile speaks for your heart.
Perfect.

The way your eyes disappear in that smile.
Perfect.

The way you give life.
Perfect.

The way *Zaire* and *Zulu* love you.
Perfect.

The way you never settle.
Perfect.

The way you teach.
Perfect.

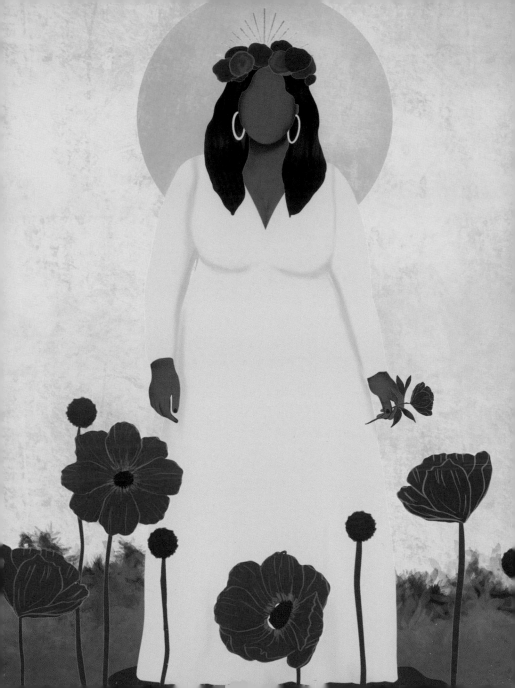

The way you melt my heart with every note you sing.
Perfect.

The way you figure it out.
Perfect.

The way you fill a room.
Perfect.

The way you fill a dress.
Perfect.

The way you wear your crown.
Perfect.

The way you plan.
Perfect.

The way you will be remembered.
Perfect.

The way you impress me.
Perfect.

Just look at you . . .
Perfect.

JENNIFER'S SONG
ODE TO JENNIFER HUDSON

The *Voice* of an *American Idol*,
with the heart of a survivor.

You love like
you know tomorrow isn't promised.
You give like
you know what it's like to not have.
You smile like
there were days when you didn't know if you would again.
You sing like
you know that's what you were born to do.

That voice came straight out of a wooden church pew
with the Bibles in the back pocket.
You sound like,
"Now turn to your neighbor,
say, 'Neighbor, I love you.'"

Doll is so proud of you.
You live the same way
that *Walter* believes in you—
with your whole heart.

You earned that Oscar
the way you play your part.

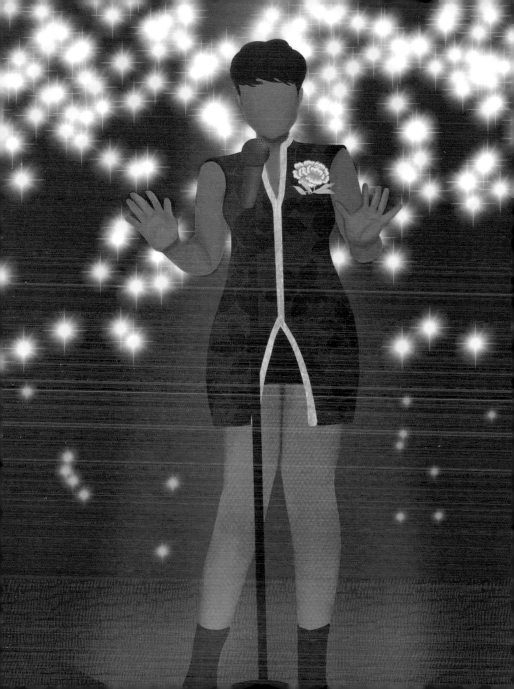

The way you grieve,
but still go.
The way you lost,
but still live.
The way you mourn,
but still manage.

You've never been paralyzed by a pause.
You and *Julia*
will always be *Doll's Dolls*.
You will always be *Julian*'s sister
and *Munch*'s momma.
Some things are just constant
no matter the context.

Your legacy
is not how much you've sold.
Your heart
is what has made you gold.

KEISHA'S SPIRIT
ODE TO KEISHA LANCE BOTTOMS

There is no church in the wild—
it resides in your heart.

The way you train up a child
can give them a head start
or a disqualification.

Major Lance taught you how to dream.
What a beautiful lesson.
How far can you go?
There's so much power
in knowing only you
can answer that question.

Ms. Sylvia taught you work ethic.
Imagination helps you be
what others can't see.
But examples,
show you how to be it—
and you've had plenty.

A bootcamp for excellence.
You were trained for this.

There is no church in the wild,
but there are scriptures
in your circumstances—
even the ones we try to circumvent
or forget.

But you have the memory of an elephant—
you don't forget where you come from,
or what you've been through.
It made you.

Now look at you—
making history.
The second of your kind,
but the first you.

Always remember how you felt
when those emotions rushed over you
in that church pew.
How sure you were
of what you were called to do.
Remember that feeling,
because that's how sure I am of you.

LISA'S PRAYERS
ODE TO LISA GREEN

I'm not a religious man,
but I have unshakable faith
in you.

I learned how to love
by watching you.
I knew your heart
before I knew you—
and I still see it clear.

Every day after school,
you'd ask me to tell you about my day—
just so I knew
I always had a listening ear.

You looked death in the face
and said, "not yet,"
just so I never knew fear.

You could've been anything you wanted
and you still chose to be my mother.
What an honor.

Such a great tour guide
through an ever-evolving amusement park—

full of rollercoasters
and wild rides.

You showed me *Psalms 23*
in living color.

You have comforted me
with your words and presence.

You have prepared tables before me
with Sunday's excellence.

And you anointed my head with oil,
pomade, grease,
or whatever my preference.

You taught me how to believe
with diligence—
how to keep showing up.

You are the cause of consistency.
I am the effect of your confidence.

Love is not selfish.
Because of you,
I know the difference.

LIZZO'S LOVE
ODE TO LIZZO

When you found your *Soulmate*,
in a reflection,
that was the day—
you and your destiny connected.
And we all benefited.

The universe can move at lightning speed,
but you changed the *Tempo*—
with flutes and high notes.

The way you love yourself
has taught us all how to be better people
just through your existence—
defined by ferocity and grace
Like a Girl.

You chose to weather the rain
just to cast a rainbow
over the world.
And, honestly, everything looks
Better in Color.

And you're a prime prism.

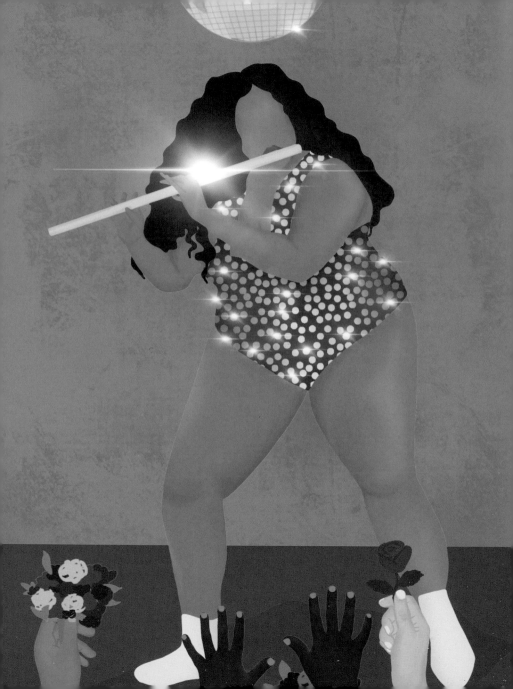

Even when the *Truth Hurts*—
it can't kill us.
And as long as you are alive,
and well,
Heaven Help Me—
you won't fail.

Your tears of joy deserve a place to call their own
because they remember nights you didn't have one;
now the world is your home.

So weep, *Cry Baby*—
you earned it.
For all the nights
that **five** turned to **five hundred,**
five hundred to **five thousand.**

You multiply—
with no intention to divide
as you rise.

And I hope you always remember three things:
—*We love you.*
—*You are beautiful.*
—*You can do anything.*

MANDY'S HEIGHT
ODE TO MANDILYN GRAHAM

I learned how to tell stories
by talking to you.
Trying to convince you of secret worlds—
always attempting to make you laugh,
as if it was a competition.
But my favorite story to tell
is how you love me.

A younger sister,
but my oldest friend.
A true marvel.
Only 4'11",
but I've never seen you
come up short.

An inspiration.
I've never seen you settle—
only push for more.

What a role model you are.
Nothing seems out of reach—
or too far.
No wonder you birthed stars.

Elizabeth and *Cassandra*
were born with an advantage.
They have you as an example
and an image.

Look at how you are love
and how you give it.
Look at the way you decide to be great
and don't wait for permission.

Every step you take
has been with intention.
You can't choose your siblings,
but you can choose your friends.

And I choose you—
over and over again.
What a beautiful bond.

We are measured in various ways,
some accurate,
some not so true.
Just know, I will always look up to you.

PHYLICIA'S ROLE

ODE TO PHYLICIA RASHAD

Have you ever noticed
the slight pause *Ms. Phylicia* takes
after she speaks?

Sometimes, it's paired with a smile—
as if to let you know
it's safe now—
you may enjoy this moment.

And on contrary occasions,
she cuts eyes,
or maintains a stoic stare—
as if to signal—
this is your moment
to ponder the previous.

In either case,
she is in control.
And that is what she always appears to be—
in control.

You feel those pauses in your soul.
She speaks in prose,
and I presume
that she got that from *Ms. Vivian.*

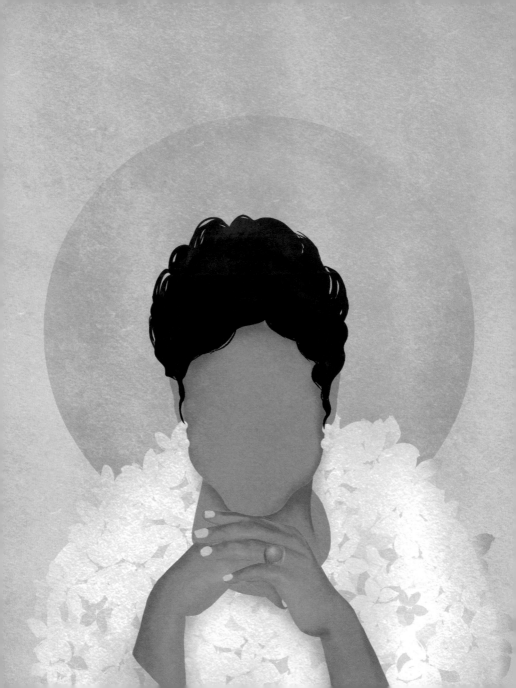

She learned how to be
and portray poised matriarch
by proximity.

She is the yielding of sisterhood.
She is the product of poetry
and aphorisms.

The universe bears her no ill,
and she bears no ill to it.

She embodies a presence
that we won't forget.

As vulnerable as *A Raisin in the Sun.*
As rare as a *Gem of the Ocean.*
As symbolic as twenty pearls.

An inspiration to so many Black girls
to be loved **and** revered.
She proves—
you don't have to choose just one.

Ms. Phylicia speaks with the cadence of a queen
and the voice of a dream.

She is the moment
right before applause.
Whenever she speaks
I'm reminded how important it is—
to just pause.

ROBIN'S AUTHENTICITY
ODE TO ROBIN ROBERTS

You sound like a safe space.
A place where secrets go
and never leave.
Where fears meet their demise.

You sound like you have nine lives,
and plan on getting the most out of all of them.
Every time you speak—
your emotions sound as clear as your voice does.

You sound like love,
like compassion,
like passion,
like you couldn't make this up if you wanted to.

You sound like connection.
I see pieces of me
in you.
You sound like a reflection.

You sound like you made your *mess your message.*
As if you turned your life into a lesson.
A masterclass on perseverance and persistence—
charm and character.

You sound like you look people in the eye
so that you never forget them.
Being so thankful
can make you welcomed.

You've been ushered into the hearts of millions
and just settled in,
made yourself at home,
and asked if you could get us anything.

You sound like a house guest with home training—
making your parents proud.
Mr. Lawrence and *Ms. Lucimarian*
have caught every kiss you've blown them,
and sent them back whenever you needed them.

You sound like the product of quiet time
and a clear mind.

Everybody's Got Something,
but you make us feel like we got somebody.

You sound like peace
In an often chaotic world
You go girl!

TABITHA'S BUSINESS
ODE TO TABITHA BROWN

Tabitha Brown should open a bakery.

She is *Pecan Pie*:
The way she reminds us to give thanks.
As southern as manners.

She is *Key Lime Pie*:
As light and refreshing,
and *Donna* is her *meringue*.
She and summer sound the same.

She is *Sweet Potato Pie*:
The way she comforts
and reminds us of family.

You have to take a *Chance*
when you're given a *Choyce*
to choose your *Quest*.

She is *Apple Pie*:
She reminds us of the best of the U.S.
Opportunity is always one leap of faith away—
even when it seems like
your dreams have faded away.

She is *Banana Cream Pie*:
Because the proof is in the *pudding*.
The strength is in the smile.

She is *Cherry Pie*:
She has turned bitter into sweet.
She has given us joy—
in the face of defeat.

She is *Blueberry Pie*:
Just easy.
Easy to listen to.
Easy to believe in.
Easy as Sunday morning.

Easy as calling *Granny*, *Momma*, and *Aunty*
to teach you culinary tricks.
A dream team
who measures *like so, and like that*—
and gives your cheek a pinch.

Who measured with a lil' bit of that
and a whole lot of this,
and that's how you came to be—
a perfect mix.

Tabitha Brown is as sweet as pie,

and that's her business.

TASHA'S STRENGTH
ODE TO TASHA BELL

You are a fond memory
and a beautiful continuum.

You've taught me
not only how to overcome,
but how to be overjoyed.

You've shown me
that everyone doesn't deserve your heart,
but those who do—
deserve all of it.

Here is my heart,
have all of it.
I trust you with it.
I know when you hand it back—
it will be in better condition.

I remember nights in *Big Girl's* kitchen—
you would ask me questions,
and actually listen.

Decades later,
you still love me—
with even more conviction.

Love grows—
I am a witness.
You are an active participant.
Jalan is so lucky—
look who God paired him with.

Look how you never gave up—
no matter what
you were dealing with.

Strength requires consistency
and diligence.
No matter what you been through—
you pushed through.

When good things happen to me—
I think of you,
because you
are one of my best things.

Your existence
brings me comfort.

I love you
and I hope you know
you are my refuge.

TRAILBLAZERS

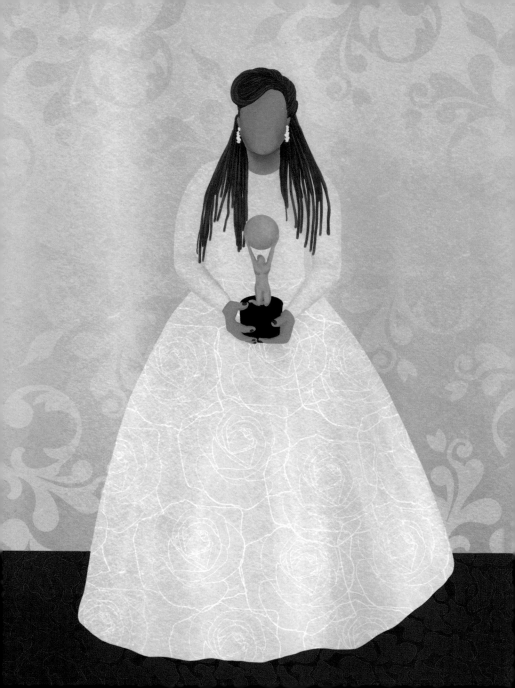

AVA'S PERSPECTIVE

ODE TO AVA DUVERNAY

The mystery of that raspy voice;
as if you've been cheering
for everyone else.
Making sure when we see us,
we see glory.

A *Daughter of the Dust*
telling our story.
Whether it's the ferocious truth,
or a whimsical whim.
It's impossible to pretend
not to see your light.

Even amongst
an **ARRAY** of majestic minds,
you are a ray of sunshine.

A stickler for the particulars.
An abolitionist who yells action.
A dreamer who takes action.

The harvest of a *Wild Seed*
at the *Dawn* of a new day.

So precise with what you say.
Pensive proclamations,
dramatic declarations,
with an overt grace.

No man is an island
and when they've dropped us
in the *Middle of Nowhere*
you've shown us our proper place.

I want to thank your *Aunt Denise*
for putting you in those cinema seats.
What she gave to you
was a gift for us all to receive.

How thoughtful of *Mr. Murray*
to help mold such a beautiful mind
and create *A Wrinkle in Time*
for you to fold into when needed.

You are legendary
but, more importantly,
you are necessary.

You're not a trailblazer,
you're a forest fire—
a creative luminary.

You have shot the idea
of freedom, brilliance, and grace
straight into our veins;
all while building an empire.
Our royal pusher.
All hail to our *Queen Sugar.*

BOZ'S BRAND

ODE TO BOZOMA SAINT JOHN

Big Business Boz
The effect
and the cause.
You've found a way
to take authenticity out of its box
and present it to the world—
as a gift.
But the truth is,
you are the treasure,
the map
with the X,
the flare
with the flex.
A combination that Black women invented,
and you keep perfecting.

Big Bow Boz
But, gift wrapping takes practice—
it's all in the presentation.
Confidence is all in the affirmation.
Who affirms like you?
Who's the greatest?
It's been confirmed,
it's you.
It's so easy to see the world clearly,
when your mirror isn't foggy.

Odupomma Boz
Queen energy.
You are the tree
that bends, but never breaks,
knows growth,
and grief;
knows bark
and leaf.
People will see what we're made of,
but the small details
is what helps them believe.

Big Believer Boz
The daughter of music makers—
no wonder you've found the rhythm of winning.
And *Lael* is your biggest reward.
Listen to how she brags on you.
The way she smiles at you—
a residual reminder
that your work is never done,
and always paying for itself.
Every time you leave her side,
you're constructing a more welcoming world
for her to reside.
And every time you return,
she's grown an inch in pride.

How does it feel
to know the greatest job you've done
is at home,
Big Boss Boz?

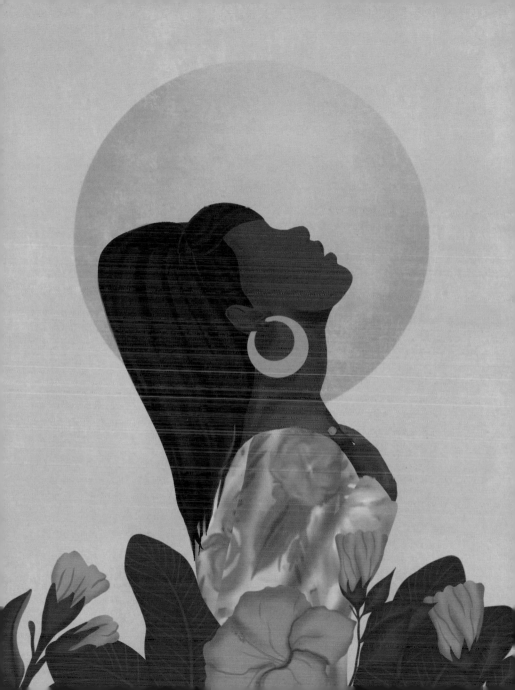

DR. COLE'S ACCREDITATION

ODE TO DR. JOHNNETTA COLE

Sister President Emeritus.
Educator Eternal.
Fire Starter.
Torch Bearer.
Baton Passer.

Higher Education in high fashion.

The fine art
of an undying passion.

The grand result of
Mr. John and *Ms. Mary Frances.*

The reflection of *A.L. Lewis*
and *Dr. Mary McLeod Bethune.*

The beneficiary of *Ms. Edelman*
and *Dr. Shalala.*

Look how tall you stand
atop those shoulders.
You've shown us
that giants only exist
with a good lift.

You've taught us that our impact
only goes as far as we reach back.

Your studies of culture
have allowed you to curate it.
A masterclass in collaboration.
A *Her*storian,
who speaks with patience
because you know the importance of time.

You've taught us
to not only *Dream the Boldest Dreams*,
but to live it.

How exquisite,
when you can erase *Lines that Divide*
and tighten the *Ties that Bind*
all through *Gender Talk*,
because when you educate a woman
you educate a nation.

But you showed us
that an educated woman
can change the world.

KAMALA'S SMILE

ODE TO KAMALA HARRIS

You smile like
you know it has the power
to change the world
and moods.

A Jamaican and Indian smile.
You smile in Baptist
and Hindu.

You smile like
they told you to stop while you're ahead
and you refused to.

Success is an assessment of stamina,
not speed,
but, somehow, you keep coming in first—
with the smile
of a gold medal winner.

You smile like
you want people to remember
that the truths we hold
are not always self-evident.

They require a place to call home.
Testimonies of tenement.
Daughter of immigrants.

You smile like
your roots run as deep as a *Thousand Oaks*.

You smile with the warmth
of a thousand coats

Your smile has become
a source of hope.
You've shown us
that *Superheroes Are Everywhere*.

You smile like
life ain't fair,
but it's worth fighting for.

Your name has been etched
in the burning sands—
in Sanskrit.
The lotus.
You don't drown in the flood—
you grow.

You smile like
you have greatness in your blood.
Like you know the power of your past.

You smile like
you are the first,
but will make sure you're not the last.

MELLODY FOR PRESIDENT

ODE TO MELLODY HOBSON

What a testament
to the benefits
of an uncanny work ethic.
You've shown us that life
is an investment.

Time is not loaned,
because it cannot be paid back.
But look at all your sweat equity.

Over all these years,
you've collected those beads
that dripped from your forehead
and created an inground pool
for you to reflect in.

There's much to be said about longevity,
but even more to be admired
in your humanity.

A **Bull** in a **Bear Market**
with a heart of gold.
Long-term value—
always appreciating.

Ms. Dorothy taught you well,
and you always put it on grand display.

Chairwoman of the Board
Wherever you go—
you're a perfect fit.
It's hard to miss a *Blue Chip*.

You are the *force*
and the enterprise.
It's in their best interest
to diversify.
And you are the why.

Who would've known
That the **Windy City**
would've taught you how to fly.
But tests of turbulence
create the most skilled pilots.
Look how long you've been eye to eye
with the sky.

And of all that you have acquired,
never forget—
that you are clearly the biggest asset.

MISTY'S EMANCIPATION
ODE TO MISTY COPELAND

Ballet is a language of the body,
and look at the story you tell.

A *Black Swan*
That had to *sauté* through hoops
just to be recognized;
only to be criticized
for being amazing.

The burden of being first
and starting late,
but you didn't *développé* overnight.

The poetry of *pirouettes* on a basketball court—
to making your *pointe*.

Blood, sweat, and years.
Leaps, bounds, and tears.
And who had the strength to lift you
every time you felt down?
Your sister circle.

The grace of the Black body
put on grand display.
But the way you have to *grand plié*

just to fit—
and you patiently became outstanding.

Broken bones,
but that can't break your spirit.
You didn't *glissade* into this position.
Nothing was given.

You earned your title
and your things.
En dehors, so they can see—
what an overcomer looks like.

You chose the fight
instead of flight,
and now you know
how it is to fly like a *Firebird*.

How does it feel to be so free
that children, once limited by our imaginations,
look at you and say,
"Mommy, that's me."

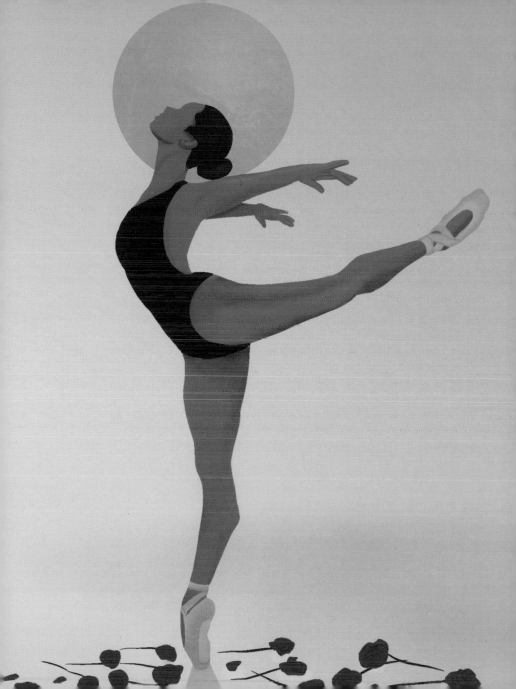

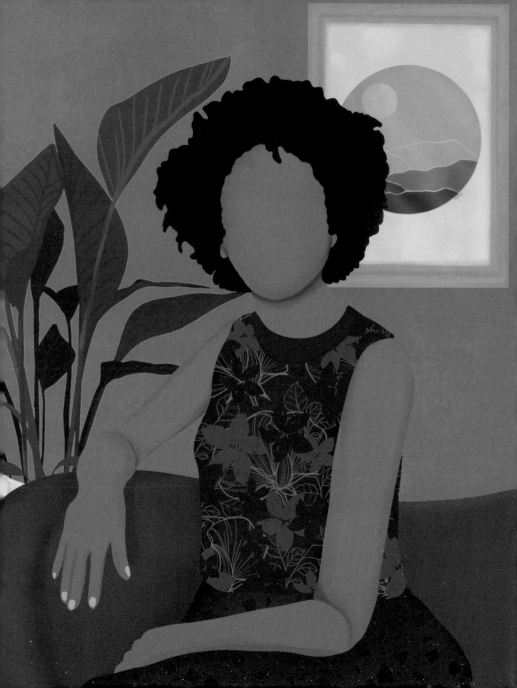

NAOMI'S TRANSLATION
ODE TO NAOMI BECKWITH

You are burgundy
A distinguished red.
A classy flame.
A reminder of wine.

A rewinder of time—
with plenty present
and plenty presence.

A *Grand Lady*.
A translator.

A dot connector—
who leaves much to interpretation,
while providing direct communication.

Mending a broken history
by breaking the rules,
because you know them all.

You stand tall
in spaces that you make sure
we stop coming up short in.

An advocate
and architect.

You are burgundy
The **green** of Hyde Park,
mixed with the **blue** of Lake Shore Drive.
Such a beautiful **brown**—
combined with a fiery **red**.

Well versed
and well read.
If church is in your heart—
then the museum is in your head.

You engineer what we see,
and you make sure
we are an exquisite scene.
Like a pebble beach
off the coast of *Hydra*, *Greece*.

The good,
the bad,
the uncomfortable.
You make sure that we're seen.

How we love.
How we rage.
How we care.
How we weep.

<u>You are burgundy</u>
A reminder
that even when we bleed—
we are a site to see.

You are the scholar
that sat by the door
and played her part
to make sure the world never forgets
that her people are *fine art*.

SHELLYE'S AMBITION
ODE TO SHELLYE ARCHAMBEAU

In life,
there will be peaks
and *Silicon Valleys*.
To see the beauty in both—
is no small feat.

You ventured into no woman's land,
filled with hyenas,
and still found a way to eat.

You turned famine
into feast.
You showed that beauty
can surely still be a beast.

You get the most out of life
when you decide not to accept the least.
You find the most out about yourself
when you decide to compete.

People have made a conscious decision—
to follow your lead,
and you don't take that for granted.

You don't just plug holes
and repair damage.
You upgrade.
You're an enhancer.

It takes a village
to raise a child,
but it takes a visionary
to raise the standard.

Look at your duality—
both village and visionary,
nurturer and nudger.

You've moved mountains—
when they weren't budging.

You learned early—
the benefits of being a nomad.
You know the life of a journeywoman
front and back—
but if excellence is a destination
you are the road map.

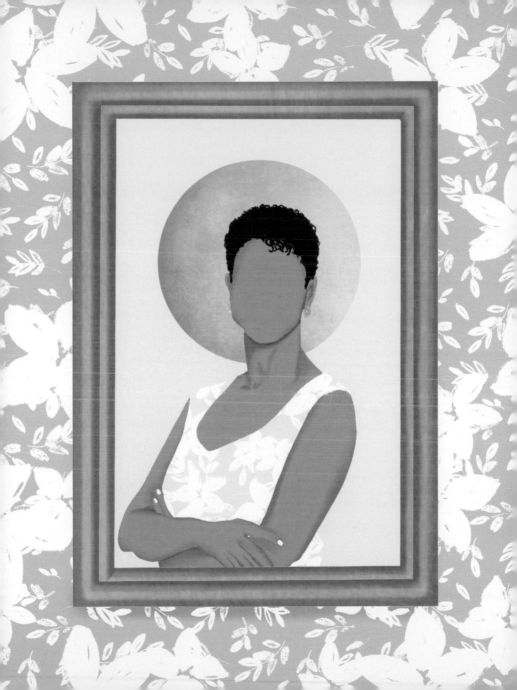

ACKNOWLEDGMENTS

I would like to acknowledge not only the Black women featured in this book but also the women who aren't. This is for the Black women I wanted to include in this book but will have to save for future volumes. The Black women whose names I will never know because they prefer to do the hard jobs in the dark. The Black women who have come before us and who have left before their time. The Black women who smiled reading this book. The Black women who cried reading this book. The Black women who did both. The Black women who thought I could have done better. The Black women who put in a good word with the universe for me. The Black women who have tirelessly supported me throughout my whole career. The Black women who work thankless jobs but do them with all their heart. The Black women who create the trends but never get the credit. The Black women who did it better but never got the recognition. The Black women who refuse to let us fail. The Black women who refuse to let us forget. Lastly, but so important, the Black women who literally helped create this book. Thank you.

ABOUT THE AUTHOR

Harold Green III is an ever-evolving artist whose vibrant story-telling and passionate lyrical delivery captivate audiences domestically and internationally. His self-published first collection of poetry (*From Englewood, with Love,* 2014) earned him a prestigious Carl Sandburg Literary Award. Green studied English Secondary Education at Grambling State University, earned a BA in Creative Writing from DePaul University, and an MH in Creative Writing from Tiffin University.

Green specializes in making poetry an accessible art form for all. The architect and curator of *Flowers for the Living,* an annual collaboration project that layers poetry on performances by Chicago's top singers and musicians, his collective was invited to perform in public spaces around the city in a partnership with the Chicago Park District.

He was a featured artist at the Chicago mayoral inauguration and the Illinois Holocaust Museum, has appeared on TEDx and at Aspen Ideas Festival, and has done commissioned work in partnership with major brands and organizations including Nike, Lululemon, Jordan, Google, Chicago Public Schools, and the Chicago Transit Authority.

Green has been featured in the *New York Times*, *Chicago Tribune*, *Chicago Sun-Times*, *The Ellen DeGeneres Show* blog, Ebony Web, Black America Web, *Windy City Live*, and Black Enterprise Web.

He is a proud son, brother, husband, father, teacher, coach, and mentor, all themes reflected in his poetry. He is a visionary, leader, motivator, and an overwhelmingly undeniable human being.

ABOUT THE ILLUSTRATOR

Melissa Koby is a Jamaican-born, Tampa-based illustrator. She fell in love with art at the age of four when her mom gifted her with her very first paint set and easel. Visual art has always been her passion and her default way of self-healing. Her illustrations are a direct reflection of how she feels.

Her work is inspired by her need to process our climate. There are themes addressing social justice, but the underlying themes are always a celebration of people of color, and the peace and tranquility that come from beautiful landscapes. The people in her artwork are faceless because she wants everyone to be able to see themselves in each piece. She wants to normalize looking past the color of skin and wants each viewer to focus on how the art itself makes them feel. All of her artwork is created using a combination of watercolor painting and digital illustration.